JUNK SCULPTURE

By
Gregg LeFevre

STERLING PUBLISHING CO., INC. NEW YORK
SAUNDERS OF TORONTO, Ltd., Don Mills, Canada

Oak Tree Press Co., Ltd.
London & Sydney

Little Craft Book Series

The author and publishers wish to thank all the children of Class 6–505, and in particular Emilio Sanchez, Nelson Lopez, and Alex Lopez, for the tremendous enthusiasm and dedication they showed in gathering junk and building their sculptures. Thanks also to the Principal of Bronx Public School No. 4, Mr. Shephard Milians, for his support in this project. Mr. John Anwyll deserves thanks for his thoughtful advice and criticism, and the author's wife, Lisa, for her invaluable assistance.

Photographs and drawings by the author Sculpture by the author except where indicated otherwise

Contents

Before You Begin

This book is designed to show you all the essentials you'll need to create your own junk sculpture, starting you off with simple projects using cardboard and other light materials, and moving you on to more complicated works in wood and metal. While specific instructions are given for the design and constructions of each sculpture, these are only suggestions, since you will certainly want to alter them and make your own original sculptures. In fact, for many projects you will be forced to do this, because you probably will not be able to find the very same junk objects used in the illustrated sculptures.

Junk sculpture must begin with junk. Generally the best places to look for junk are dumps, refuse areas, vacant lots, and areas near deserted buildings. You might also try your own attic, basement, garage, trash can, or trash put out on your street on collection days. If all else fails, you can always go to a regular junk-yard or car parts lot.

Methods and Materials

There are several things to keep in mind when collecting metal junk for standing sculptures. To start with, find a solid base for your sculpture. Sections of planks, boards, beams, logs or heavy metal objects, if they rest evenly on a flat surface, make good bases. Hub caps and inverted pots and pans can also be used, if holes for attaching other items can easily be hammered through them.

In choosing the other junk objects to include in

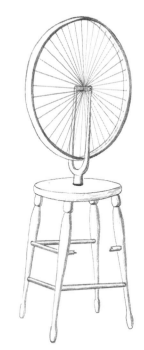

Illus. 1. "Bicycle Wheel" by Marcel Duchamp, 1913. (See page 44.)

your sculpture, select pieces which either already have holes and brackets, so you can bolt them together easily, or which are thin enough so that you can make holes. There are nine different methods for joining junk presented here. You can use screws, nuts and bolts, and washers, nails, or paper fasteners to join some kinds of junk. Glue or solder (see page 26) can be used for others. Tying junk together with wire or string is also a possibility. Finally, certain shaped junk forms can be wedged or hooked together.

There are only a few common tools which you will need. These include a tin-can opener, a saw, a hammer, a screwdriver, a pair of pliers, a wire cutter, and a sharp knife. A soldering iron or soldering gun is very useful for some projects, but nuts and bolts will usually work just as well. In addition, you will need a pair of work gloves.

The type of paint you need will depend upon the kinds of materials which you plan to paint. Spray paints are usually the easiest to use and work well on all metal, wooden, and most plastic surfaces. They cannot be used on plastic foam because they dissolve it, and they don't work well on paper or cardboard. The only drawback to using sprays is that a piece must be disassembled and the parts painted separately if more than one color is to be used.

Both latex and acrylic paints are also easy to use. They clean up quickly because they are water-soluble. However, they both have some undesirable features. Latex scratches easily. Also, rust bleeds through it, and so it is not recommended for rusty surfaces. Acrylic is expensive and doesn't cover well with just one coat on many plastic and metal surfaces.

Household paints and enamels can be used, but they take a long time to dry and are difficult to clean up.

Finally, tempera or school poster paints, while they are ideally suited for paper or cardboard surfaces, don't hold well at all on metal or plastic.

There are also several notes of caution which should be mentioned before starting. First, junk is dirty and often sharp or rusty, so it is a good idea to wear gloves to protect your hands while working. Secondly, if you are using spray paint, make sure the area where you are working is well ventilated. Thirdly, if you do use a soldering iron or gun, remember to unplug it when you're finished working.

Lastly, use common sense when working with any tools: don't work too close to someone else, and make sure that the object you're working on is securely in place.

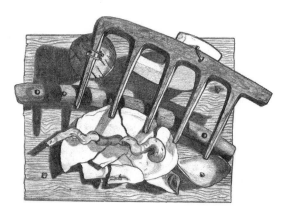

Illus. 2. Another early junk sculpture, by Kurt Schwitters. (See page 44.)

Egg-Carton Sculpture

There are no limits to the size and complexity junk sculpture can be. Rodia's "Watts Towers," for example, are made from cement, scrap steel, chicken wire, and all kinds of other junk materials. They took 33 years to build and stand almost 100 feet tall! One of Jean Tinguely's kinetic junk sculptures was constructed with over 400 junk objects, including a piano, a bathtub, and dozens of wheels.

However, before tackling any giant metal construction, start out with a simple sculpture involving easily accessible materials, such as the egg-carton sculpture in color Illus. 13.

To build this sculpture you will need a small cardboard box (the base box in Illus. 8 measures 11″ × 9″ × 9″), several moulded cardboard egg

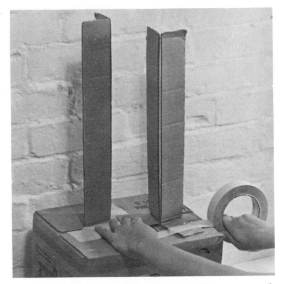

Illus. 4. Invert the box and erect the two cardboard supports from its base.

cartons, two unwaxed paper cups, and a flat piece of corrugated cardboard, 8″ × 15″. You'll also need a dozen 1″ paper fasteners, some masking tape or packaging tape, and a scissors.

First, invert the box, and from its unopened bottom set up two vertical cardboard supports. Make the supports by cutting four 2″ × 15″ strips of cardboard. Then carefully fold over 2″ at the base of each strip so that it makes a right angle.

Next, lay two of these strips next to one another so that they touch lengthwise. Then run a piece of tape down the unfolded part of the seam where the two pieces touch, joining them together (Illus. 3). In the same fashion, tape

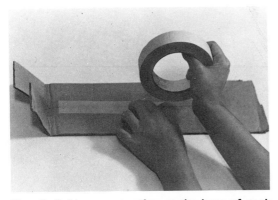

Illus. 3. Fold over a section at the base of each strip, and then tape the strips together in pairs.

together the other two cardboard strips. Now fold each pair of strips along this taped seam to make a right angle.

Following this, tape both strips to the base box (Illus. 4). They should be positioned about 3″ apart, with one side of each parallel to the front of the box. Then lay the 2″ flaps which were folded over earlier flat against the horizontal surface of the base box, and tape down securely.

These two cardboard structures can now be used to support the egg cartons. Before you attach the cartons, cut them into sections which form the various elements of your design (Illus. 5). Here, the lid of each of the two cartons has been removed, and the bottom halves folded lengthwise down the middle, so that the bottoms of the six hollows on either side which hold the eggs face away from each other. With certain shaped cartons, you may have to cut through

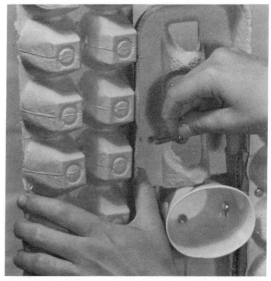

Illus. 6. Position the egg carton sections on the supports and fasten them on with paper fasteners.

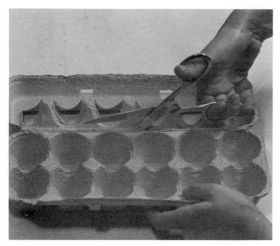

Illus. 5. Cut apart and fold the halves of the egg cartons in two.

some of the webbed material between the hollows so that they can be folded in this way.

Attach the cartons to the cardboard supports by first positioning them; then cutting a hole through the carton and the support; and finally, pushing a paper fastener through and spreading its prongs (Illus. 6).

Position the two folded egg-carton bottoms on the outside tops of each support (Illus. 7), and fasten one of the carton lids to the lower inside of one support, and half of the other lid above this between the two supports. The last step involves placing and fastening the two paper cups.

However, instead of copying this design, why not make one of your own? Much larger egg-

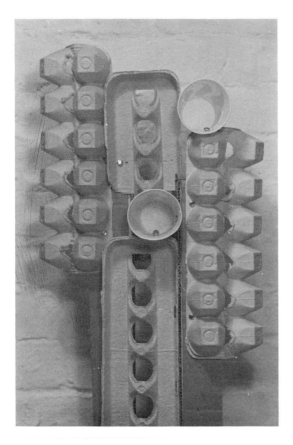

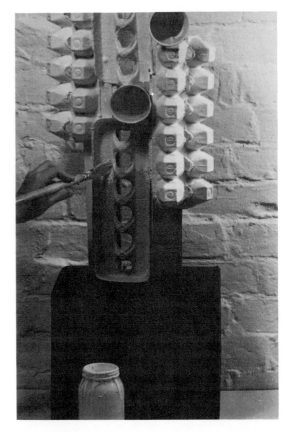

Illus. 7. The two paper cups are also attached with paper fasteners. You can make a larger sculpture by making more and bigger supports and using more egg-carton elements.

carton sculptures can be done simply by building stronger and more elaborate cardboard supports and attaching a greater number of cartons.

It's better to wait until the entire construction is finished (whatever its size) before painting it. The carton sculpture in Illus. 8 was painted with white tempera, and the base with black. In general, tempera is the best paint for cardboard and paper surfaces.

Illus. 8. You can use tempera to paint your completed egg-carton sculpture. See the finished piece in color Illus. 13.

Egg-Mobile

Eggs in cases are divided in layers and protected by moulded cardboard trays or separators (Illus. 9). When grocers re-package eggs they usually discard these separators. There are all sorts of ways they can be utilized in junk sculpture.

To make an "Egg-Mobile" (color Illus. 14), carefully cut an egg tray into six equal strips. Then decide on a color scheme and paint the strips with tempera. Next, poke a hole in the middle of the end of each strip and tie on a piece of thin string. Coat-hanger wire, or some thinner wire, can be bent with pliers to make the cross-supports: each one has a downwards loop at either end and an upwards loop in the middle. When the wires, strings, and strips have all been tied together as in color Illus. 14, spray-paint the wires and strings white.

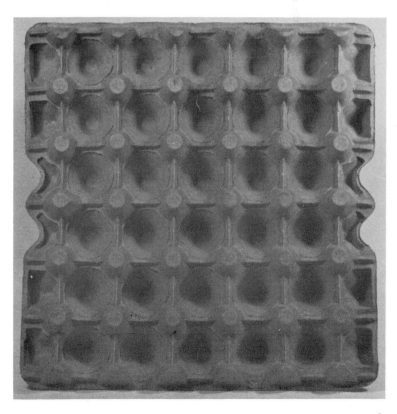

Illus. 9. A moulded cardboard egg tray can be used in any number of ways to make a junk sculpture, such as the egg-mobile in color Illus. 14.

Fruit Tray Wall Relief

Fruit in cases, like eggs, is separated into layers by cardboard or plastic trays. These trays (and egg trays too) can be painted to make an attrac-tive wall relief. Use tempera paints for cardboard trays and spray or enamel paints for plastic trays. After painting, attach to cardboard backing with paper fasteners, or hang as they are. A string tied between the opened fasteners on the back serves as a hanging wire.

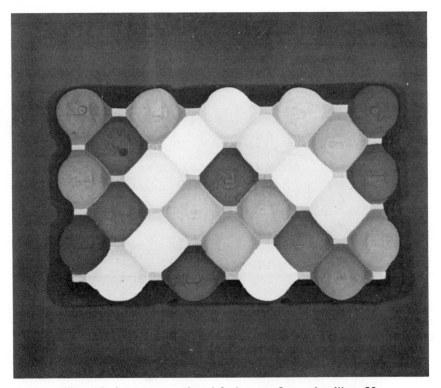

Illus. 10. A tempera-painted fruit tray. See color Illus. 33.

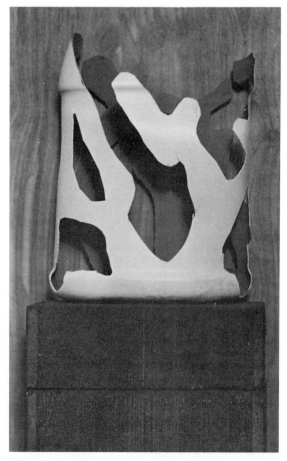

Illus. 11. See this plastic bottle sculpture in color in Illus. 18.

Plastic Bottle Sculpture

"Topless Mountains" (Illus. 11) was made from a one-gallon anti-freeze bottle, but any other plastic container can be used for the same purpose. First, sketch a design on a plastic bottle and cut it out with scissors. Next apply spray, latex, or enamel paint. If the inside and outside are to be painted different colors, only one color can be sprayed on and the other must be brushed on. The outside of "Topless Mountains" was sprayed with enamel, the inside was brush-painted with purple latex, and the base box upon which the sculpture rests was brush-painted with flat black latex. (See color Illus. 18.)

While this sculpture is quite abstract, plastic bottles can be used to make more realistic forms, such as figures holding hands in a circle, or birds with swept-back curved wings. Round handles on some plastic bottles can be incorporated into a design as the head of a figure.

11

Plastic Foam
Junk Sculpture

A Wall Sculpture

The wall piece in Illus. 12 was made from discarded plastic foam used in the packing crates for a sewing machine, a casserole dish, and an electric fan. Foam pieces can be re-shaped with a razor or file to form a design. A back support can be made from wooden slats or heavy cardboard.

The foam pieces can be glued both to each other and to this backing. Only certain glues can be used with plastic foam, such as rubber cement and spray adhesive. Plastic cements will dissolve the foam.

The finished construction should be painted by hand with either enamel or latex. Remember, spray paints and some plastic paints will dissolve plastic foam, and tempera will not stick to it.

Plastic foam blocks can be assembled to make interesting standing sculpture. Thick foam pieces can also be carved, filed, or sanded to create unique forms.

Carved Plastic Foam Fountain

The fountain in color Illus. 19 is an example of how large pieces of discarded foam can be carved into almost any shape. A razor, file, rasp or sandpaper can be used to re-shape the foam. A fountain like this one, however, is a very difficult piece to execute. After you have gained sufficient experience, though, you might like to tackle something similar.

The first step in building a fountain is to carve out a plastic foam shape. Then drill or carve tunnels through the foam where rubber tubing which you will use to conduct the water will run. The diameter of the drainage tube should be about twice that of the tube which emits the water. Lastly, attach an electric water-pump to the tubing. The arrangement used for the pump, fountain-head and drainage tube will depend upon the specific design of your fountain and the pump that you use.

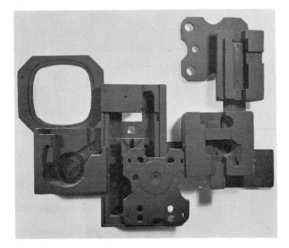

Illus. 12. "Factory." 36" x 27"; plastic foam protective supports from packing crates; painted with flat black latex; on a T-shaped support.

Illus. 13. Untitled. 12" x 9" x 31" (front width, side width, and height); 2 egg cartons, 2 paper cups, cardboard box and supports; painted with black and white tempera. (See page 6.)

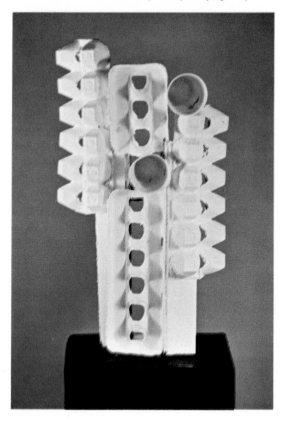

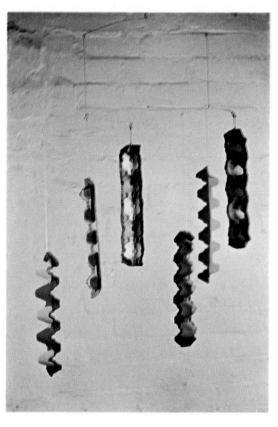

Illus. 14. "Egg-Mobile." 24" x 36"; cardboard egg-tray strips, string, and wire. (See page 9.)

Wooden Sculpture

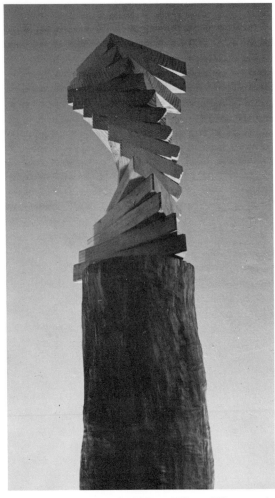

Illus. 15. "Stack II." 11" x 11" x 43"; wood scraps, steel rod, log base.

The triangular scraps of wood composing the sculpture in Illus. 15 were salvaged from the trash at a wood-working shop which makes stairs. You will need nothing more than a metal rod or wooden dowelling for assembling.

To construct a similar piece, start by drilling a hole, slightly larger than the rod or dowelling, in each wood scrap. Then thread each piece onto the rod or wooden dowelling. Now, you can turn the individual pieces in different directions until you reach a configuration which you like. Following this, glue them in place. A section of a log, turned upright, makes a perfect base.

A fairy-tale castle is easily made from a variety of wood objects. Start with a small baseboard. The one in Illus. 16 measures 10" × 7". Then glue spools together to form columns, using the largest spools, or other wooden shapes. Two spool columns connected at the top by glued ice cream sticks makes an interesting gate or arch. Other towers can be made by glueing together small wooden blocks, or dowels.

Make the turrets from decorative bottle tops, or by either filing plastic foam scraps into pointed forms or by glueing together some wooden pegs used on the backs of picture frames. Yarn running from one of the tower tops to holes drilled in the baseboard adds a drawbridge effect.

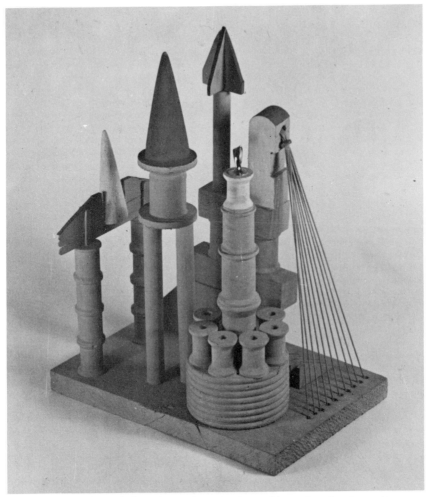

Illus. 16. A number of thread spools and other odds and ends of wood scraps are all that are required to make a fairy-tale castle. See color Illus. 25.

Mixed Media
Junk Assemblage

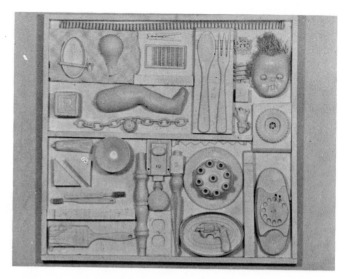

Illus. 17. Untitled. 26" x 24"; ¼" plywood backboard, assorted wood strips, and from left to right, top to bottom: wire spring, anchovy can, light bulb, foam-rubber backing, clothespin, plastic hair brush, wooden spoon and fork, metal royal crest, short spring, rubber doll's face, plastic toy alphabet block, doll's leg, chain, champagne cork, plastic block, doll's hand, toy wheel, toothpaste tube, 2 wooden triangles, 2 toothbrushes, metal horn, 2 wooden chair-arm supports, door lock, twisted car engine dip-stick, nasal mist container, toy flying saucer, plastic distributor cap, paint brush, electrical-outlet cover plate, toy gun, oval sardine can, and a plastic telephone body.

If you have a great assortment of odd pieces of junk such as in Illus. 17, you might want to make an assemblage. You will need a large rectangular or square piece of plywood or Masonite (pressed board) for a base, and a number of smaller strips, slats, and blocks of wood to begin an assemblage like the one in Illus. 17.

First, make a thin wooden frame around the circumference of the base board. Then arrange the other wooden strips and blocks into compartments to hold the junk objects you have collected. After finding an arrangement which you like, nail or screw on these wooden strips and blocks.

Now, attach your junk objects. Use nails and screws where possible, and glue on any oddly shaped or fragile objects. Then attach two screw-eyes and a hanging wire to the back. The final step is spray-painting the entire assemblage. The piece in Illus. 17 took three coats of flat white spray enamel.

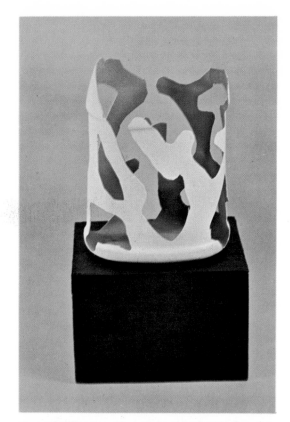

Illus. 18. "Topless Mountains" by Emilio Sanchez, age 11. 9" x 7" x 15"; plastic anti-freeze bottle and a wooden camera-shipping box; painted with spray enamel and latex. (See page 11.)

Illus. 19. "Banana Split." 24" x 20"; carved plastic foam, plastic tubing, and an electric water-pump; painted with yellow enamel. (See plastic foam fountain, page 12.)

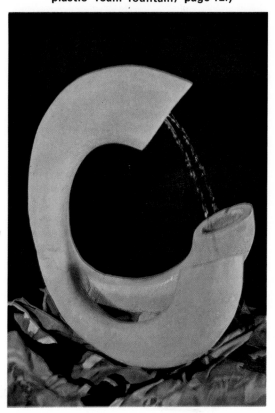

Found Objects

A single piece of junk can sometimes make an interesting sculpture. "Found Objects" is the title often given to such sculptures. Both of the pieces in Illus. 20 and Illus. 21 were "found" just as they appear and mounted on a base block. The stove burner in "Mother and Child" was painted and then bolted onto the base block. The shaft of the cast-iron section in Illus. 21 was inserted into a broken cinder block and wooden wedges were hammered in to secure it.

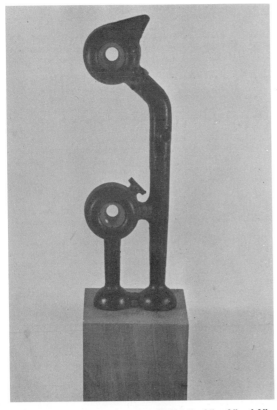

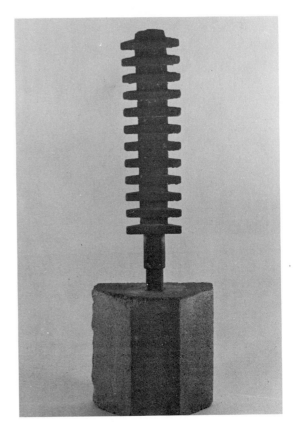

Illus. 20. "Mother and Child." 6" x 6" x 14"; stove burners painted with enamel, mahogany block base.

Illus. 21. Untitled. 8" x 4" x 23"; piece from cast-iron furnace grid, cinder block.

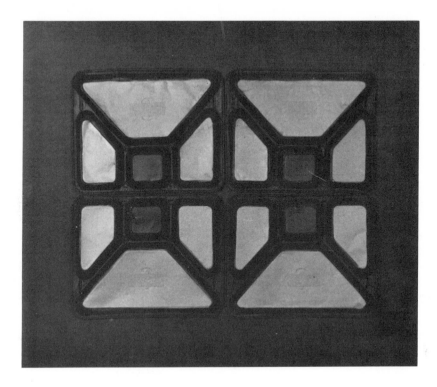

TV Dinner Tray Sculpture

TV dinner trays can be used to make a junk wall sculpture. For best results, carefully remove the dinners from the trays before eating, because utensils will dent the aluminum (unless you want a dented effect). After cleaning four trays, paint them with enamel or spray paint. The bottoms were painted for the sculpture in Illus. 22, but painting the insides works just as well. Next, nail holes in the corners and attach the trays to a posterboard or cardboard backing with paper fasteners. A hanging wire or string can be tied between these on the back.

Tin-Can Wall Sculpture

A tin-can wall sculpture such as the one shown in color Illus. 38 is a little more difficult to make than the other projects you have done up to now. To begin, you need a bunch of tin cans and jar tops, a short board, and the tools mentioned on page 5.

The easiest place to find cans and lids is in your own kitchen rubbish. If you can't find enough there, ask your friends and relatives to save them for you, or dig into someone else's trash. (If you burrow into someone's trash, always make sure that you pick up anything that spills.) A construction site or a lumber-yard is the best place to look for a scrap lumber backboard.

Once you have collected everything, clean all the cans and lids. Wash them out and peel off the labels. Also remove the plastic and cardboard sealers from the lids and tops. If any dirt or paper is left on the cans when they are painted, the paint probably will not hold.

Remember, too, that the insides of the cans and tops may be sharp. *Wear gloves when you work.*

Next, place your cans and lids on the board and experiment with different arrangements and designs. When you have made a design which you like, carefully move it off of the board, one can at a time, and set it up in the same way on a piece of newspaper off to the side of your work space. This is done so that you won't forget where each can goes as you work on the rest of the project.

Now make holes in the cans and lids so that they

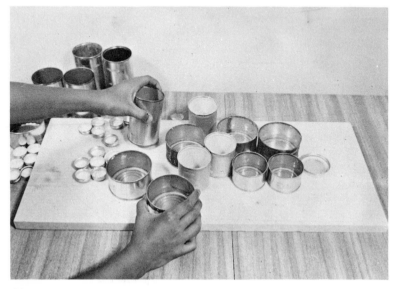

Illus. 23. Arrange the cans, lids, and tops in a design which you like.

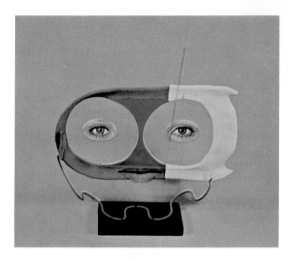

Illus. 24. "Double Head Light." 7" x 5" x 14"; automobile headlight bezel (faceplate), automobile seat spring, string, magazine cutouts, and a pine baseboard; painted with latex.

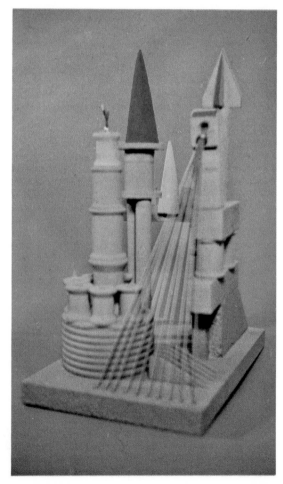

Illus. 25. "Camelot." 10" x 7" x 13"; 21 thread spools, 7 ice-cream sticks, 100" of yarn, wooden trophy base, 3 sections of a $\frac{1}{4}$" dowel, 4 short rectangular wood scraps, perfume bottle top, and 9 wooden pegs. All painted with tempera. (See page 14.)

can be attached to the backboard. To do this, take one can at a time from the design, turn it bottom-up, and with a hammer and a heavy nail punch a hole in the middle of the bottom (Illus. 26). As you finish each hole, replace the can or lid in the same position on the paper and take the next one to work on. When you have finished them all, you are ready to start painting.

You should give careful consideration to the colors you choose. Too many colors will detract from your design. It is best to paint your cans and lids with two or three colors which go together well, and then paint the background a dark color so the design will stand out.

The sculpture in color Illus. 38 was painted with

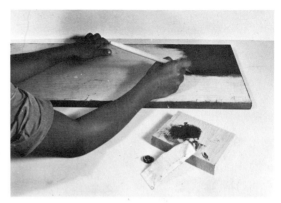

Illus. 27. Paint the edges and the front side of the backboard.

four different-colored acrylic paints: titanium white, manganese blue, cobalt blue, and a mixture of cobalt and white.

First, paint the backboard. Then, just as with making the holes, paint only one can at a time and place it back into the design on the newspaper.

Illus. 26. Make a hole in the middle of each can, lid, and top.

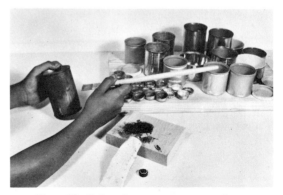

Illus. 28. Paint the cans one at a time.

When everything has dried, begin attaching your tin-can design. One at a time, place a can or lid in position and then nail it onto the board (Illus. 29). You should use short nails, so they will not go all the way through the backboard, and they should have wide heads, so that the cans and lids are held on tightly.

The lids and shallow cans can easily be attached in this fashion. However, with the taller cans it is more difficult to pound the nails all the way in. Such cans can be securely attached either by using a nail set to push the nail in all the way (Illus. 30), or by turning in a screw instead.

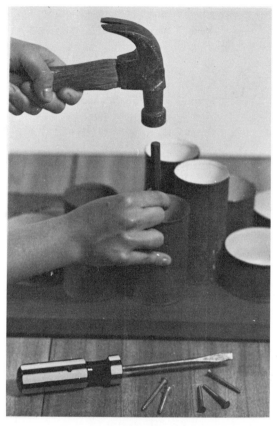

Illus. 30. For the tall cans, use a nail-set to finish pounding the nails in, or turn a screw in instead.

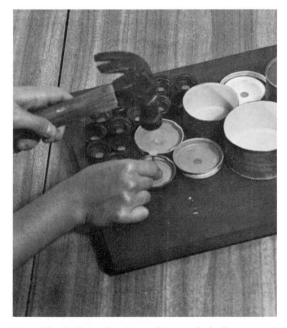

Illus. 29. Nail on the tops, lids, and shallow cans with a hammer and nails.

Next, attach a wire to the back of the board so that you can hang your piece (Illus. 35). Drill or hammer two small holes at either end of a line parallel to the top edge of your board. Then twist in two "screw eyes" like the ones in Illus. 35, or

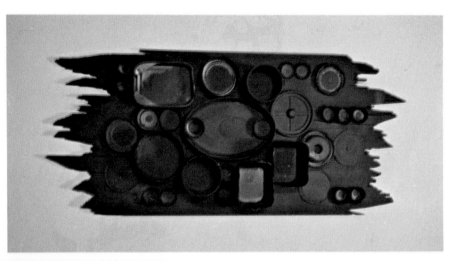

Illus. 31. Untitled. 26" x 11"; broken piece of lumber, vegetable cans, sardine cans, corned beef cans, and plastic tops; spray-painted with flat black. The jagged edges were trimmed to balance the design.

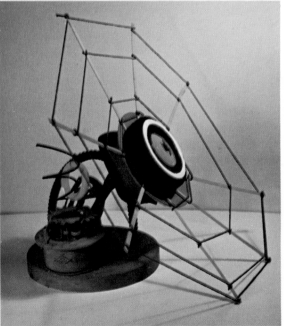

Illus. 32. "La Cueva Del'Araña" (the cave of the spider) by Oscar Gomez, age 12; record-player turntable, clock-works, bed spring, rubber ring, metal desk-lamp neck, 2 metal pot lids, toy tire, 8" metal bracket, wooden mustard sticks, string, and a coffee percolator basket; painted with tempera.

Illus. 33. Untitled. 32" x 20"; tempera-painted fruit tray, paper fasteners, and a posterboard backing. (See page 10.)

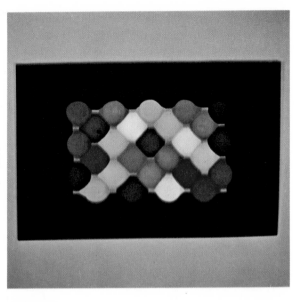

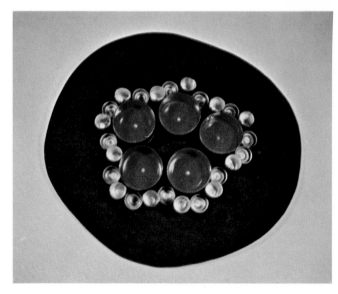

Illus. 34. Untitled. 21" diameter. The backboard in this wall sculpture was cut with a jig saw from a discarded piece of $\frac{1}{4}$" plywood. The red tuna cans and the black backboard were spray-painted separately. Then the tuna cans were nailed on, and the small silver film canisters and lids were attached around them. (A number of film companies sell their film sealed in such canisters.)

pound in two thin nails and then bend them down with a pliers or hammer. Attach a double length of wire between the eyes or nails as shown in Illus. 35. Once this is done, your tin-can sculpture is finished and ready to hang. Now how about a name for it?

By using different sized and shaped cans and backboards, all sorts of tin-can wall sculptures are possible. You can also add on other materials, such as wood scraps, spools, bottle caps, string, and wire, to give your tin-can design more variety.

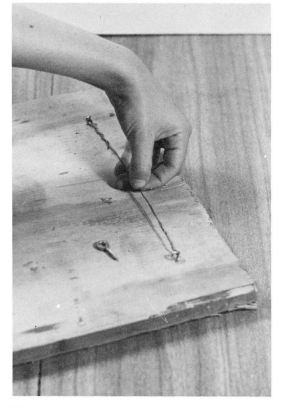

Color Illus. 31, 34, and 39 are only a few of the different projects you can do in this way.

Tin-Can Tower

You can approximate the original design for a tower such as in color Illus. 44 by arranging cans on the floor and then viewing them from above. Attach the cans together in one of three different ways: glue them together, using small wooden stir-sticks and glue between the vertical cans to be positioned side by side; bolt them together, using the same procedure suggested for screwing the cans down in the wall sculptures (page 23); or solder them together.

To achieve a strong bond in soldering, you must first remove all grease, dirt and oxide from the two metal surfaces to be joined. Flux can be used to clean oxides from the surface. Next, heat both surfaces with a soldering iron or gun, and after they are hot, apply the solder. Use acid core solder for iron, and multicore solder for non-ferrous metals (copper and brass). There is also a solder especially designed for soldering aluminum.

Regardless of how you attach the cans, it's best to start with a central core of 3 or 4 large heavy cans, and then attach the other cans one or two at a time. Prop them into position with blocks, wedges, or hold them in place with masking tape, cellophane tape or a clamp. Then solder, glue, or nut-and-bolt them.

Illus. 35. Attach a hanging wire to the back of your piece. Screw eyes or bent-over nails can be used to attach the wire.

Wire Sculpture

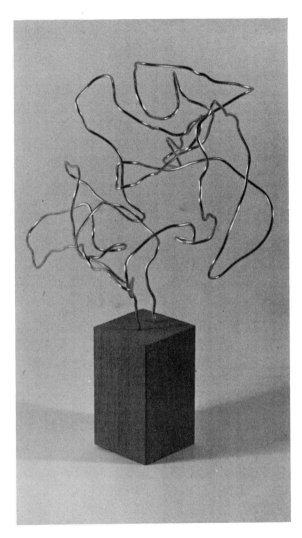

A wire sculpture is quite easy to do. All you need is a base block and a 5' or 6' length of pliable wire. First, on the top of your base block, drill two 2" holes of a diameter slightly larger than the wire being used. Next, insert both ends of the wire into the holes and experiment with different wire designs until you arrive at a final form. Finally, remove the wire, paint the base block, and then glue the wire back in place.

Wire sculpture is unique in that it can be re-shaped as many times as you like. While the design in Illus. 36 is abstract, you might prefer realistic outlines in wire. Alexander Calder, the famous mobile artist, has done a number of different wire outline figures, including a clown, a cow, and even a whole circus peopled with wire forms!

Illus. 36. "Tongue Tree" by Alex Lopez, age 11; 10" x 10" x 17". Redwood base block (3" x 3" x 6") painted with orange enamel; and a 6' length of $\frac{1}{8}$" aluminum wire.

Metal Strip Sculpture

While a chrome strip from the side of an automobile was used for the sculpture in Illus. 37, you can use any form of long metal strip for the same purpose. Aluminum siding, counter siding, or metal framing strips can all be employed in similar sculpture. Or, bolt shorter pieces together to make strip designs.

Begin by applying masking tape in several lines along the entire length of both sides of the metal strip. Spray-paint the strip. Remove the

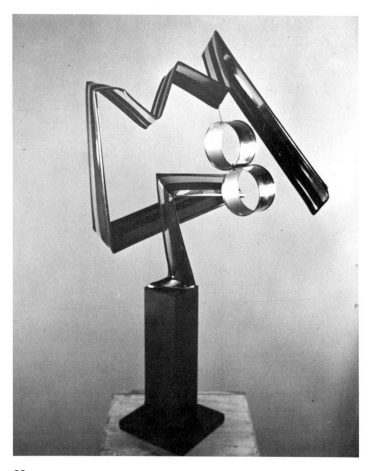

Illus. 37. Untitled. 19" x 14" x 35"; 7' x 4" chrome automotive siding strip, 2 tuna fish cans, redwood base.

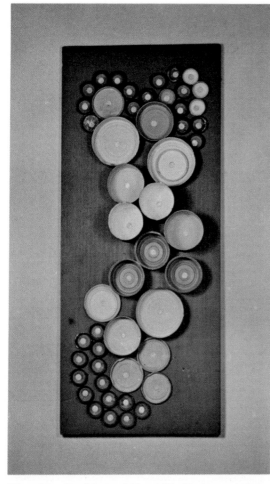

Illus. 38. Untitled. 26" x 11"; 12 tin cans, 7 jar lids, 33 bottle tops, discarded lumber; painted with acrylics. (See page 20.)

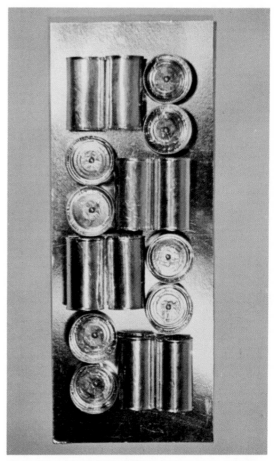

Illus. 39. Untitled. 29" x 12"; soup and tuna cans, cardboard backing, covered with aluminum foil. To do this, evenly apply rubber cement to all the parts that are to be covered by aluminum foil. Smooth on the foil and rub out wrinkles with the rounded back of a comb. Then attach the cans to the backing with paper fasteners. Hammer the holes in the cans before you remove the tops, to avoid crushing the cans.

29

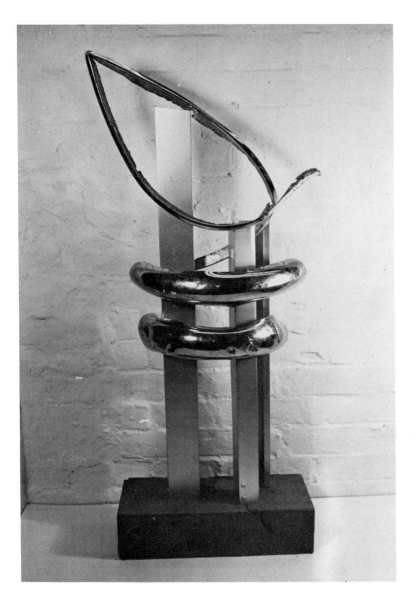

Illus. 40. "Chrome on Chrome." 20" x 6" x 45"; 3 aluminum counter-siding strips, 2 tricycle fenders, chrome automotive strip, 3 L braces, and a 4" x 6" beam section base.

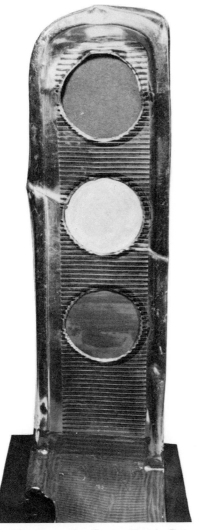

Illus. 41. "Cross on the Green, Not in Between" by Maria Figueroa, age 11. 12" x 12" x 27"; aluminum auto tail-light panel, construction paper, and plywood base.

tape and you should have stripes of color alternating with the metal finish.

Next, use a piece of wire the same length as your strip to experiment with different designs. When you have worked out a suitable design, bend the strip into the same configuration.

Then bend over a short portion of the bottom end of your strip, make several nail holes in it, and screw it down to your base block. A redwood 4 × 4 mounted on top of a pine-wood square was used for the base block in Illus. 37.

To add motion to your piece, bolt together two tin cans with the tops and bottoms removed, and suspend them on a string or wire from the strip design.

A piece like "Chrome on Chrome" (Illus. 40) can be constructed from a number of other materials besides those used here. Start by fastening three vertical strips to a base block. The longer strip in Illus. 40 measures 39" × 3", and the two shorter strips 31" × 3". They are all fastened to the base board with L braces and screws.

Next, solder or bolt on the two cross-pieces. Tricycle fenders were soldered in place in the illustration. Finally, shape a metal strip by bending or twisting it, and then solder it onto the tops of the vertical pieces.

Cross on the Green, Not in Between

In the sculpture in Illus. 41, red, yellow, and green construction-paper circles are taped to the back of the panel, showing through the holes on the front. A 4" section of the panel is bent over and nails are driven through it into the painted plywood baseboard.

Metal and Mixed Media Sculpture

Clown with Hat

All the different pieces of junk in Illus. 42 were used in constructing "Clown with Hat" (color Illus. 49). Most pieces were chosen either because they already had holes or brackets and could be easily attached, or because they were made out of a material light enough to be easily pierced.

You won't find, naturally, the exact objects used in this clown, but you can follow the same general procedures for assembling a figure of your own.

The first operation involves driving holes into the hub-cap base so that the central support for

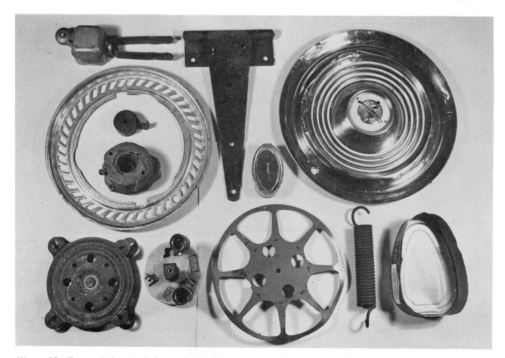

Illus. 42. From left to right, top to bottom: desk lamp arm base, T-hinge, hub cap, wheel ring surrounding small metal spring and carburetor section, anchovy can, pulley, light socket, film reel, heavy spring, and ham can.

Illus. 43. "Homunculus." 9" x 8" x 21"; pickle jar with colored water, vegetable can, tuna can, juice can, hair-roller spring, plastic coffee lid, metal fork, vacuum-cleaner hose, large nut and bolt, magazine cutouts; painted with red enamel spray paint.

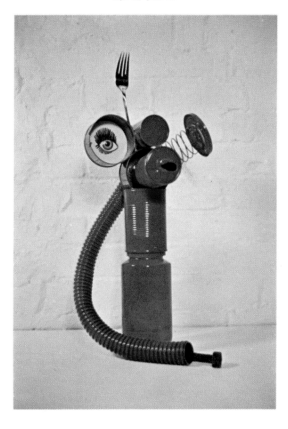

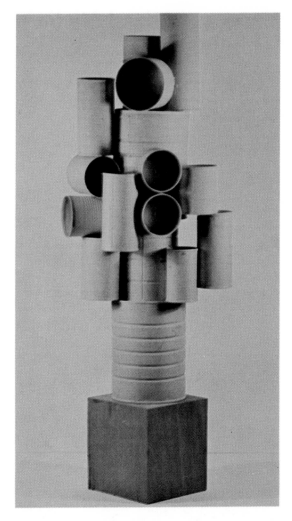

Illus. 44. "Tin-Can Tower." 11" x 8" x 31"; 3 large coffee cans, 5 soda cans, 3 beer cans, 4 vegetable cans, 3 tuna cans, and one small juice can; sprayed with flat yellow; resting on a mahogany base block. (See page 26.)

the rest of the sculpture, in this case a large T-hinge, can be bolted in place. To do this, first mark where the holes are to go, and then hammer the holes using either a heavy nail (like a masonry nail or spike) or a nail punch. The safest way to do this is to hold the nail with a pair of pliers (Illus. 45).

Then bolt the square end of the T-hinge onto the hub, holding the nut from one side with a pliers and turning in the bolt on the other side with a screwdriver (Illus. 46). Because the other end of the hinge is still free to move, use thin wire to secure it in place.

On top of the vertical hinge, bolt on the pulley (Illus. 47). This was a well chosen piece of junk because it contained a number of different-sized holes and four side sprockets to which things could be attached.

You can then paint the piece.

Next, drive a hole through the ham can. Insert a bolt through this hole and through the middle hole in the film reel, and then attach both to the hole, half-way up, in the vertical hinge.

Following this, bolt the triple light socket onto

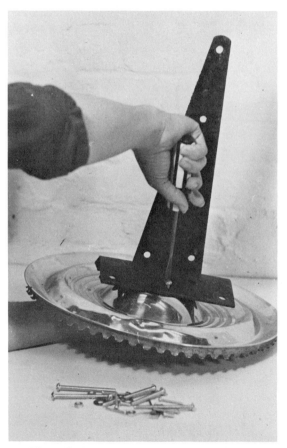

Illus. 46. Bolt the hinge onto the hub cap.

Illus. 45. Hammer holes in the hub cap.

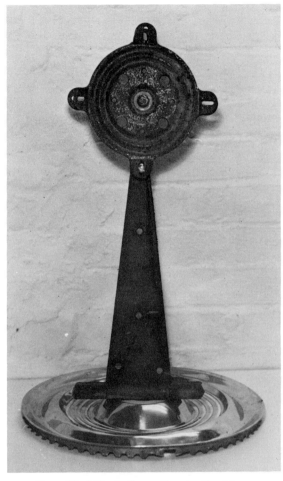

Illus. 47. Attach the pulley to the hinge.

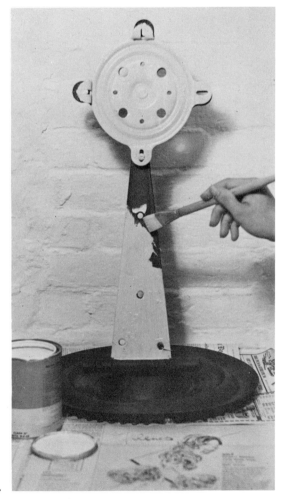

Illus. 48. Paint the piece.

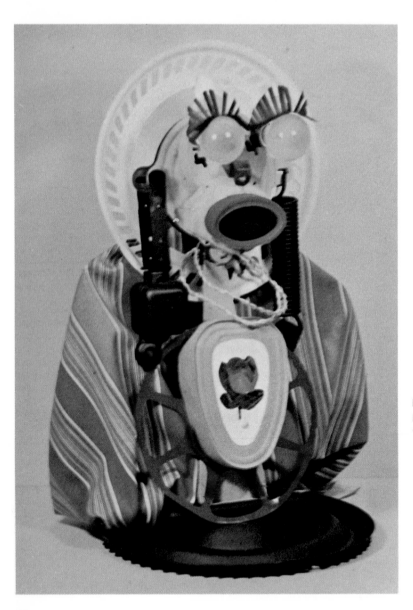

Illus. 49. "Clown with Hat"; painted with latex and enamel. (For materials, see Illus. 42.)

the face of the pulley. Break off the lower socket leaving the two remaining sockets to serve as eyes, and the metal lamp-shade brace between them to serve as a nose.

Now solder an oval-shaped anchovy can onto the carburetor section (Illus. 50). Use either a soldering gun or soldering iron. (See page 26.) Then bolt the carburetor section with the anchovy can soldered to it to the face of the pulley below the sockets. The oval can forms a mouth and the carburetor section forms the cheek, jaws and lower face.

Next, on either side of the clown's face (the pulley), attach the "earrings"—on one side the spring is hooked in place, and on the other, the desk-lamp arm base.

At this point, squeeze a short section of tubing

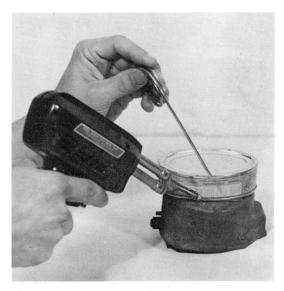

Illus. 50. Solder can to the carburetor section. (See page 26 for soldering instructions.)

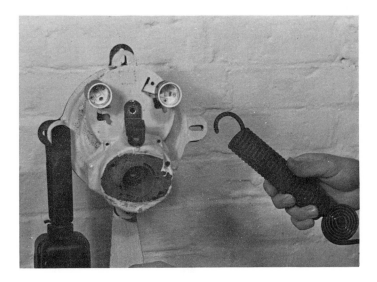

Illus. 51. Hook the spring "earring" in place.

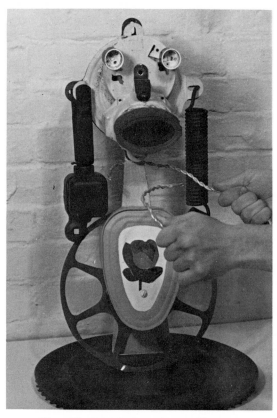

(aluminum, plastic or rubber will do) onto the top sprocket of the pulley. Use wire to tie the wheel ring (the white painted circular "hat" in Illus. 49) to a hole made in the top of this tubing. The tubing simply elevates the wheel ring so that it encircles the face.

Finally, the entire piece can be painted.

Several finishing touches can be added after the paint dries. Twist on a wound-wire necklace, paste on a magazine cut-out flower, screw in two light-bulb eyes, and cut paper eyelashes for them.

As a finishing touch, a scrap cloth can be pinned round a coat hanger hung from the back of the pulley, which gives the clown a cape.

Illus. 52. Attach the wire necklace.

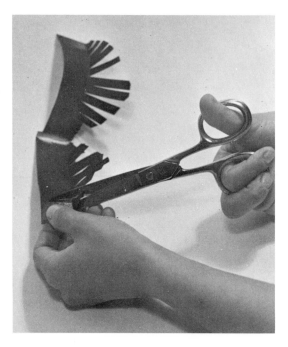

Illus. 53. Make paper eyelashes, if you wish.

Junk-Go-Round

To begin a "Junk-Go-Round," hammer a hole through the middle of each hub cap and then make eight more holes at regular intervals around the rim of one of the hubs. Tie a piece of string from each of these holes to a piece of junk. Finally, attach a hub with screws at either end of the central wooden support and then paint with any kind of paint. (See Illus. 54.)

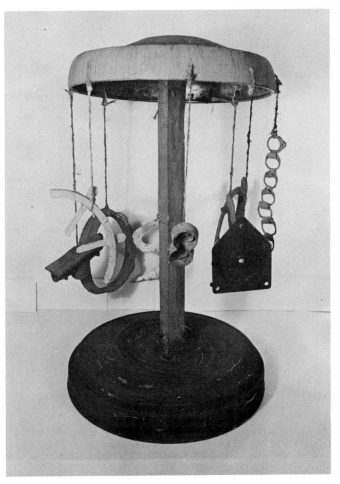

Illus. 54. "Junk-Go-Round" by Evelyn Luciano, age 11. 26" x 14"; 2 hub caps, telephone receiver hook, pop-bottle tops, broken sections from a picture frame, flower pot, stove burner, window scraper, and a plastic caster; painted with 7 different colors of latex.

Boing

The construction in Illus. 55 was made by simply threading the pop-top chain, the wheel and the pulley onto the spring, and then twisting it through a hole in the base box. Then the metal bumper hook was bolted down and the different parts were painted with red, green, and blue latex paints.

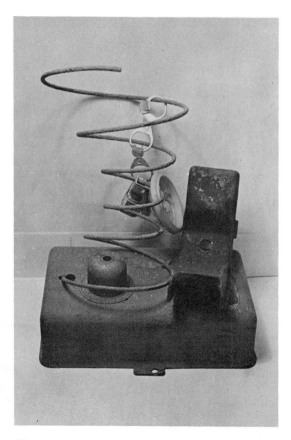

Junkman and the Ms.

In spite of size and weight, large constructions such as Illus. 56 are not difficult to make. While you will probably not be able to collect the same junk parts to start with, the following instructions will provide some ideas for assembling the junk you do have.

A sewing machine turned on its side is mounted to the base block by driving heavy spikes into the block and then bending them over, around the machine. Next, the table leg is attached to the sewing machine, through a hole, using a nut, bolt, and washer. Then the meter top and the muffin tin are mounted on the vertical table leg with screws.

The bicycle sprocket with the air hose slid around its stem is now hammered into a large hole in the sewing-machine body. The truck spring can then be lowered down around this sprocket, and the oxygen-tank cap forced down onto the sprocket above it, holding the spring in place. Both the long narrow spring and the fuel pump tube can be hooked onto the coils of the truck spring. Finally the toilet tank float is threaded onto the free end of the narrow spring.

Illus. 55. "Boing" by Sandrea Lopez, age 11. 10" x 5" x 12"; mattress spring, 4 pop-bottle tops, window-shade pulley, toy wheel, bumper hook from an auto jack, and an electric outlet box; painted with latex.

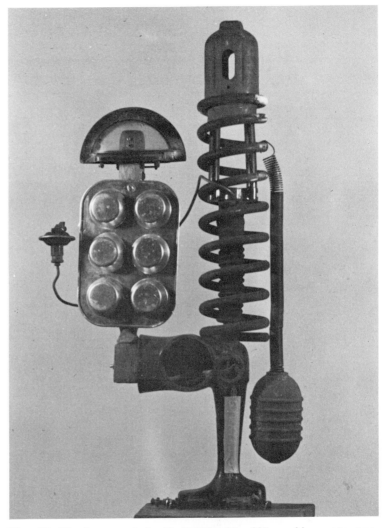

Illus. 56. "Junkman and the Ms." 19" x 9" x 36"; parking meter top, table leg, muffin tin, fuel pump and tubing, sewing-machine body, 17" truck spring, bicycle pump and air hose, oxygen tank cap, 15" spring, toilet-tank float, and a wooden beam base.

Martian Sunday Hat

The sculpture in Illus. 57 is also very easy to assemble. Hammer the chair leg into the engine casing hole. Then hammer a nail through the agitator top and the strainer, into a hole on top of the engine casing. Then use any type of paint. Imaginative figures such as this are so easy to construct, using only a few materials, that you should find no end to ideas. Often the shapes of the junk you find will immediately conjure up images in your mind.

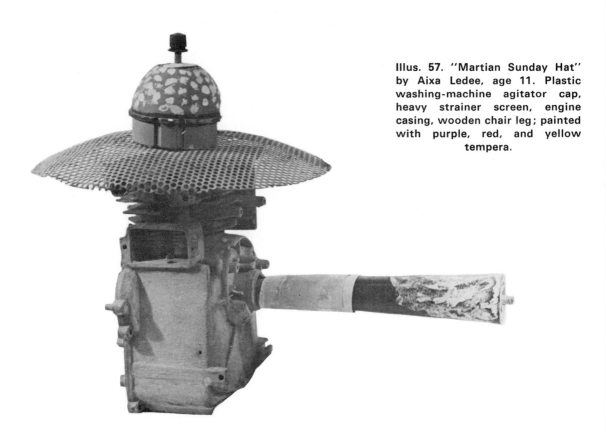

Illus. 57. "Martian Sunday Hat" by Aixa Ledee, age 11. Plastic washing-machine agitator cap, heavy strainer screen, engine casing, wooden chair leg; painted with purple, red, and yellow tempera.

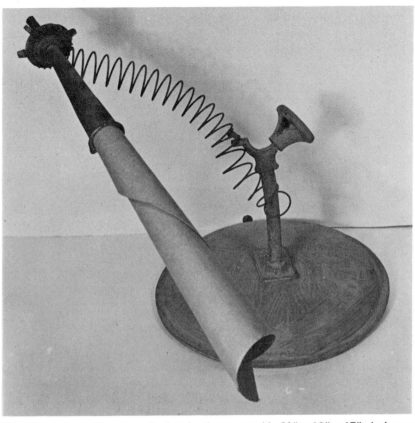

Illus. 58. "Crazy-Horn" by Evelyn Luciano, age 11. 20" x 12" x 17"; hub cap, pipe brace, lamp fitting, party horn, construction paper, and a spring; painted with enamel. This is a kinetic junk sculpture.

Crazy-Horn

When pushed, the piece in Illus. 58 gives a long-lasting and unique series of motions. To build one like it, bolt a pipe brace onto a hub cap; then twist a long spring onto one side of the brace top, and another junk object on the other side, like the lamp fitting. Next, thread a party horn onto the free end of the spring. By inserting some rolled construction paper into the mouth of the horn you will throw it off balance, and add to the crazy motion of the piece.

43

The History of
Junk Sculpture

"Junk Sculpture" is not really a movement in art, in the sense that surrealism or pop art are. Junk is simply another means of artistic expression, in the same way that wood, or plastic, or clay are. As you can see by looking round you, junk is remarkably abundant, and so diverse in size and form that its possibilities are endless. Junk can be formed into almost anything, from realistic representations to the most abstract shapes that imagination can conceive of, and it has earned a respected place in all schools of sculpture.

Junk was probably first used in sculpture during the 1910's and 1920's. The "Dadaist" movement, an artistic movement that emphasized the irrational and helped lay the groundwork for surrealism, made use of junk as a means of expressing the rejection of traditional art forms. The Dadaists were pioneers in that they made use of many objects and techniques that had never before been used for creating art.

In 1913, one of the most famous Dadaists, Marcel Duchamp, exhibited a piece entitled "Bicycle Wheel" (Illus. 1 on page 4). It was simply a bicycle wheel and sprocket mounted upside down on an old kitchen stool. Needless to say, his piece caused a huge uproar in the art world.

In the years that followed, Duchamp exhibited many other found objects, including a bottle rack, a urinal, a coal sack, and a hat rack suspended from the ceiling. He called these pieces "Ready-mades" and classified them as non-sculpture.

Kurt Schwitters, a German Dadaist, also created a number of works using junk as his medium. He felt that there was no substance which could not be used to create artistic harmony and pleasure. At first, he assembled collages, using cloth, paper, newspaper clippings, and so on. However, Schwitter's later works included all sorts of junk: broken tools, scrap wood, wire, machine parts, buttons, sea shells, and the like. However, these assemblages were mounted on a backboard and designed to be viewed from only one side (see Illus. 2).

His most ambitious junk sculpture (if it truly is one) was a building completely remodelled with all kinds of Dadaist art, junk, and discarded relics.

Max Ernst, although primarily a Dadaist painter, also created some junk collages and assemblages. His first collages were carefully pieced-together designs consisting of scrap paper, clippings, labels, and wrappers. However, he soon moved towards more three-dimensional forms, making sculptural collages by fitting together small sections of scrap lumber, dowels, and poles, and then painting them.

Pablo Picasso was also beginning to incorporate junk into his art at about this time. As he developed his cubist still lifes he sought to reproduce the feel of the subject matter by similarly texturing the painted surface. Then he began including real objects themselves on his canvases. As with Schwitters and Ernst this move began by adding newspaper, cloth scraps, and cardboard. However, Picasso used these junk materials much more freely than did the Dadaists, working over and round them with color.

As time went on, Picasso's collages and constructions became more three-dimensional, and included wood scraps, sheet metal, wire, and heavy cardboard. The canvas or backboard was completely dispensed with in some of these, but his works were still designed to be viewed from one side only.

"Violin and Bottle on a Table" (1915) provides a good example of such constructions (Illus. 59). Made with sections of scrap wood, wire, and part of a table leg, it stands $18\frac{1}{2}''$ high.

It was not until the mid-1930's that Picasso's

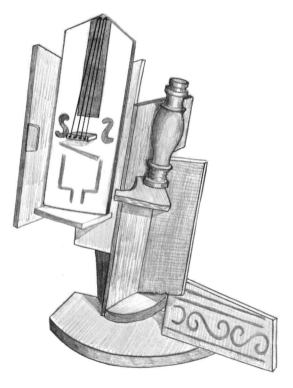

junk sculptures evolved into standing forms meant to be viewed from all sides. At that time he made a number of wooden stick figures. Some were carved from a single piece of wood, while others were constructed from a number of wood scraps and decorated with cloth, rope, and string, with painted-on features.

During the 1940's, very few sculptors worked with junk. One notable exception was Joseph Cornell. His most well known works consist of tiny junk treasures enclosed in old, well-polished wooden boxes with glass faces. Each box is a small, silent world containing cherished objects like an old clay pipe, a Haitian postage stamp, an ancient photograph, or a tattered, yellowed old map.

During the 1950's a number of sculptors began to experiment more with junk. Richard Stankiewicz, for instance, welded together heavy scrap cast-iron pieces—boilers, tanks, metal grids, and cowlings—to create junk sculptures. "Instruction," a piece done in 1957, provides a good example of his work. In it a heavy, vertical, cylindrical machine part with an upraised arm, seems to address a smaller, squat piece of machinery (Illus. 60).

The automobile has provided a rich source of materials for junk sculpture. The immense variety of parts, from small, complex engine parts to gleaming chrome bumpers and curved hoods, provide endless combinations and arrangements for junk sculpture.

Jason Seley in the early 1960's introduced some large junk sculptures made entirely from auto-

Illus. 59. "Violin and Bottle on a Table" by Pablo Picasso, 1915.

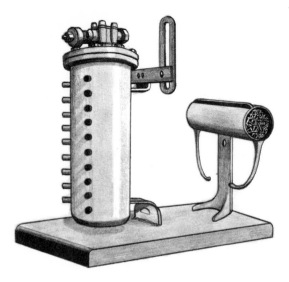

His most famous junk sculpture was a contraption called "Homage to New York." It was assembled with 15 motors, a piano, a bathtub, and 400 other junk objects salvaged from dumps, including dozens of wheels of all shapes and sizes, pulleys, belts, and rollers.

In 1960, during an exhibit at the Museum of Modern Art, in New York City, this machine was to destroy itself. With Tinguely at the controls, amid an array of noises and flying machine parts, the machine caught fire and was destroyed by firemen trying to put out the flames. Few junk sculptures, before or since, have commanded so much attention.

Mark di Suvero also builds interesting works, using mainly old metal and wooden beams, chains, ropes, and auto tires. His works impress the viewer with a feeling of frozen movement. They are usually large constructions with heavy beams and other linear forms juxtaposed at different angles so that the work seems off-balance. While most of his pieces look like they may fall over any moment, they are really very solid (see Illus. 61).

Very few generalizations can be made about the different artists who have used junk in their work. Some, like Duchamp, Schwitters, and Ernst, were revolting against what they saw as a narrow and rigid approach to art. Others, like Picasso, were interested in giving more texture and reality to their work by incorporating actual objects. Still others, Tinguely and Chamberlain for instance,

mobile bumpers. Seley gets his material from junkyards. He arranges them—adding a bumper here and subtracting one there—until he's struck by an idea for a sculpture. Then he begins to weld.

John Chamberlain constructs large sculptures from metal automobile body panels. Some of his works consist of whole automobile sections— doors, fenders, hoods—welded to one another. In other works he uses a scrap metal compressor to crush the pieces together.

Some sculptors have created junk sculptures with moving parts. Jean Tinguely, a Swiss-born artist, is one of these "kinetic" sculptors. He assembles parts from electrical appliances and machines into sculptures which groan, shake, and jitter, but do very little else. Tinguely has constructed machines that spin so fast they seem to disappear; that draw their own abstract art; and that build and destroy themselves.

are reacting in their work to technology and machines. Finally, there are a number of sculptors who simply wanted certain effects which could only be achieved through the use of a particular junk material.

Junk is different from other materials used for sculpture because of its intimate and symbolic connection with man and our society. A piece of junk is more than just trash. It can have a whole story behind it, such as the boxed keepsakes that Joseph Cornell used in his works, or it can have its own special and unique beauty, that waits only for the right eye to see it. The automobile headlight bezel on the front cover probably sat for years in a junk yard or vacant lot, no more than another piece of ugly trash. And yet all that time its beauty and potential were there, merely waiting to be released. Almost any piece of junk can be completely transformed simply by looking at it in the right way.

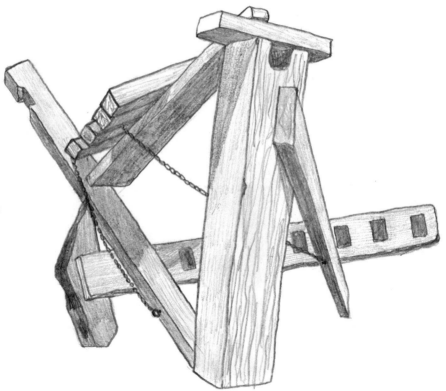

Illus. 61. A construction by the modern sculptor, Mark di Suvero.

Index